Photos of Original Artworks

By Sabrina Royce

8/11/2015 Edition

Photos of Original Artworks by Sabrina Royce
Copyright © 2015 Sabrina Royce

All rights reserved. No part of this publication may be reproduced, distributed, or transmitted in any form or by any means, including photocopying, recording, or other electronic or mechanical methods, without the prior written permission of the publisher or author.

For permission requests, visit the publisher at www.createspace.com . Or visit the author at http://sabrinaroyce.healthcoach1.integrativenutrition.com/
ISBN-13:987-1516861002
ISBN-10:1516861000
Printed in the United States of America

This book is dedicated to all my life teachers, my ancestors and all protective forces.

With gratitude I acknowledge all who have inspired and supported me toward the creation of these Artworks and this book.

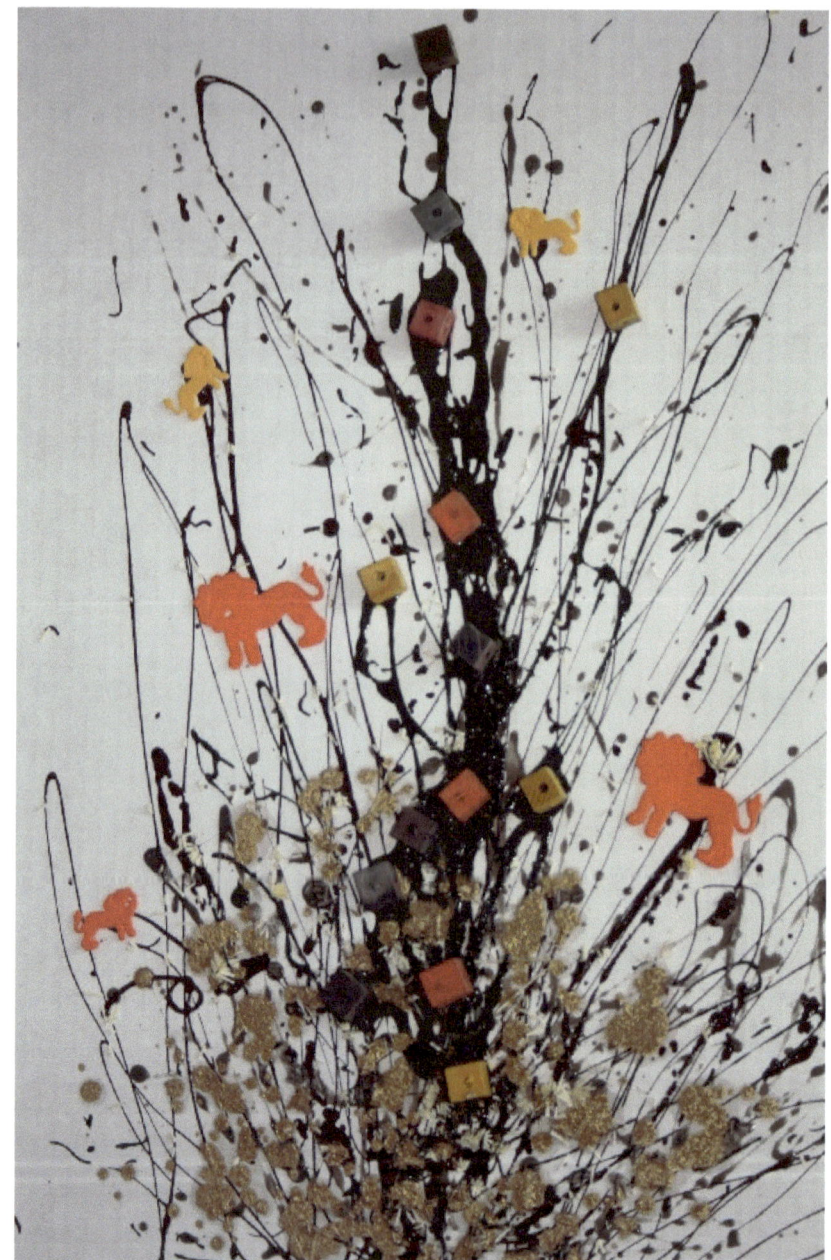

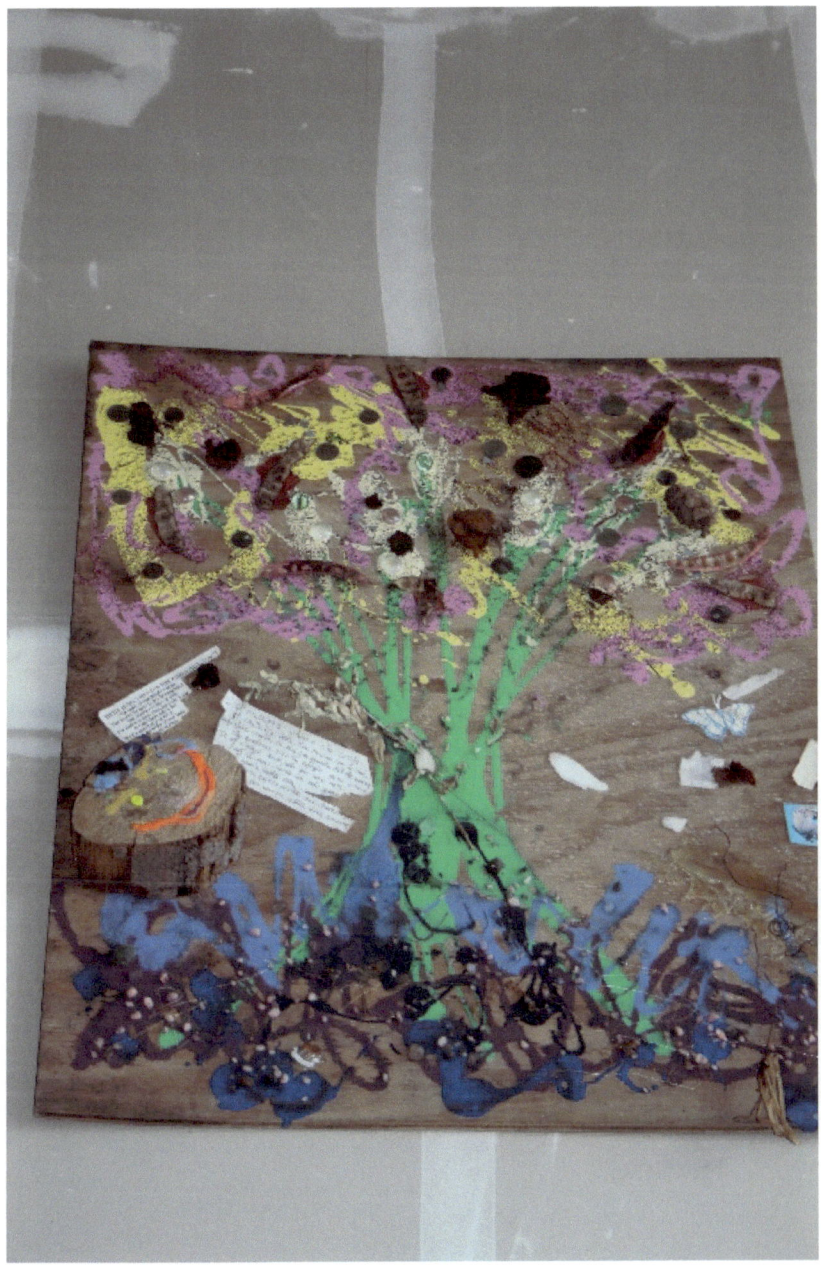

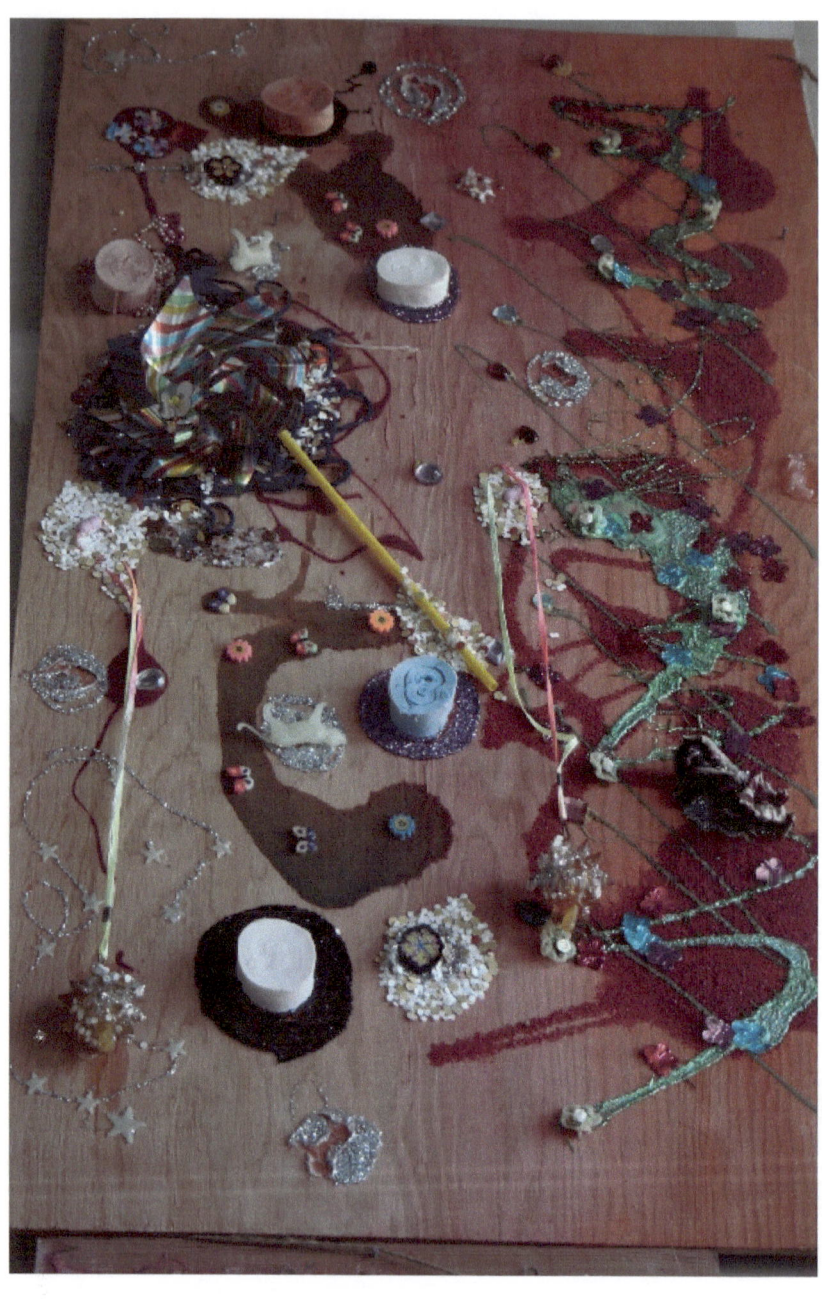

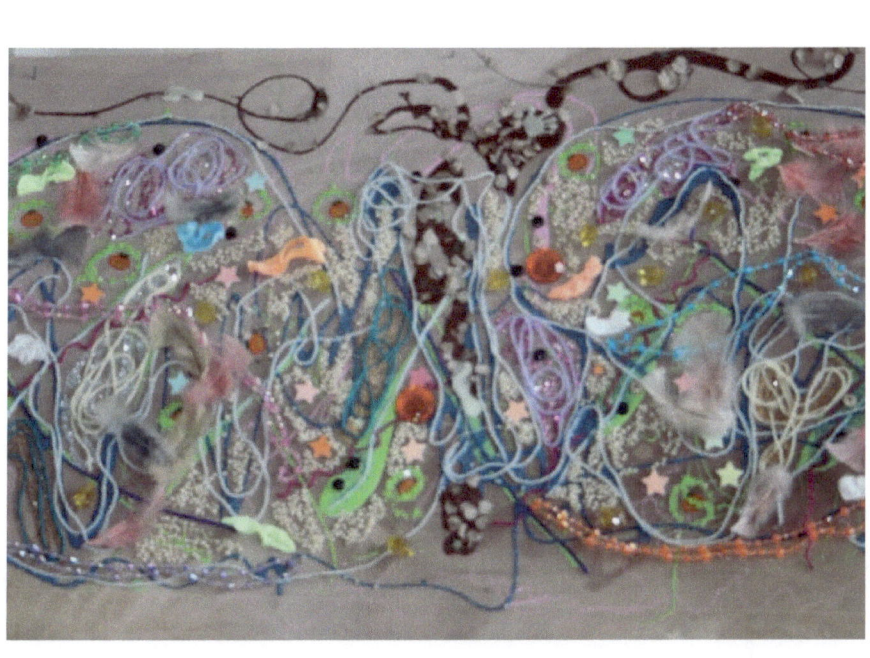

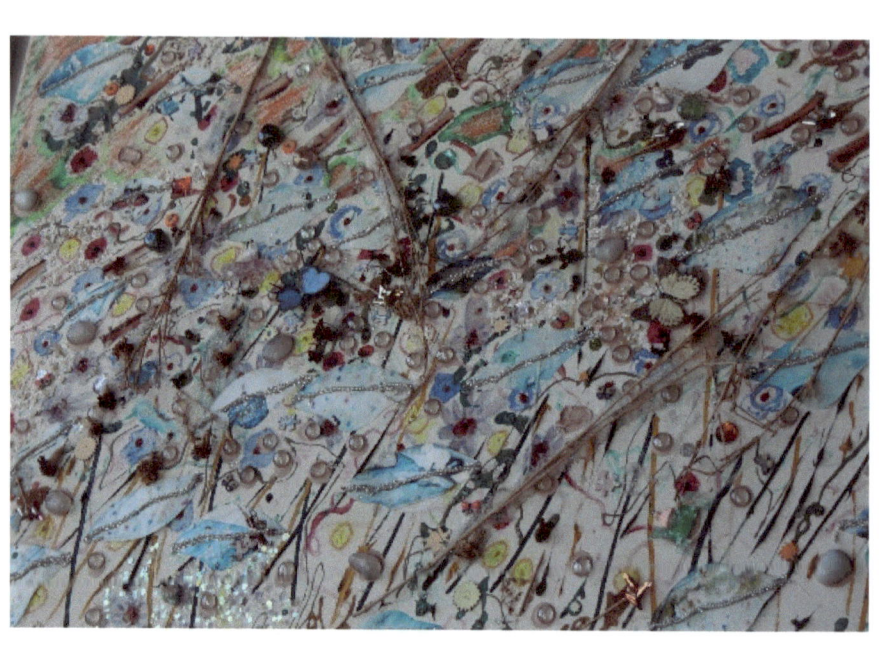

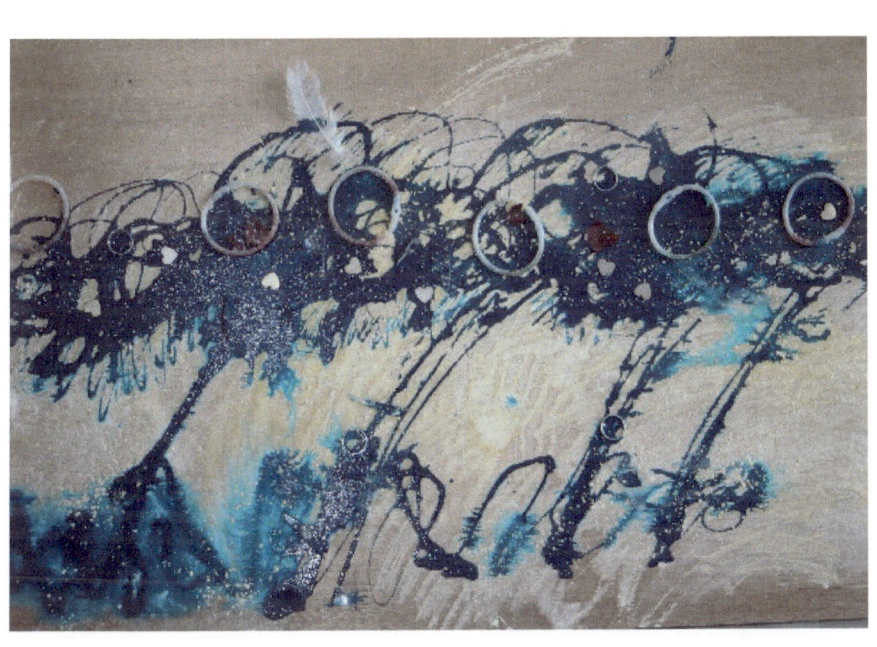

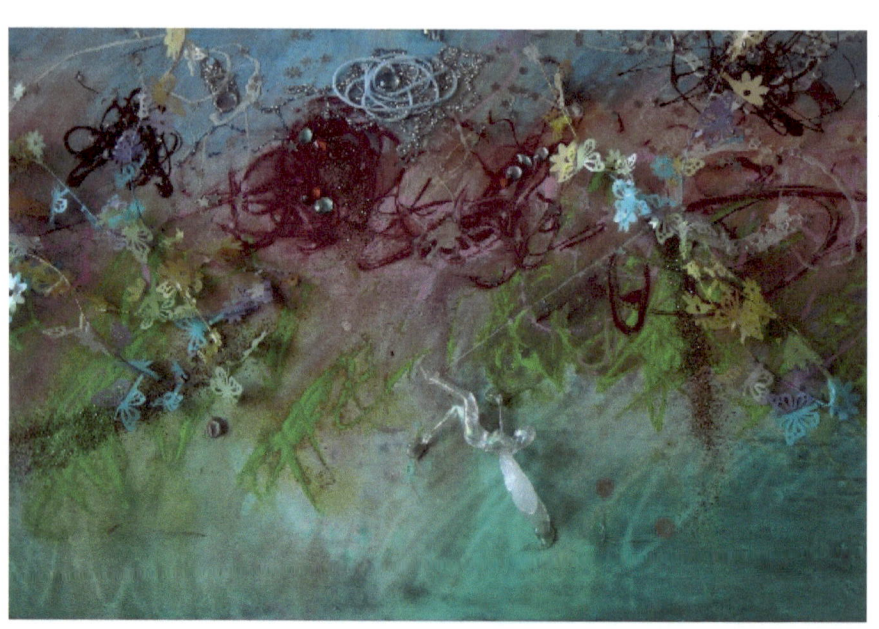

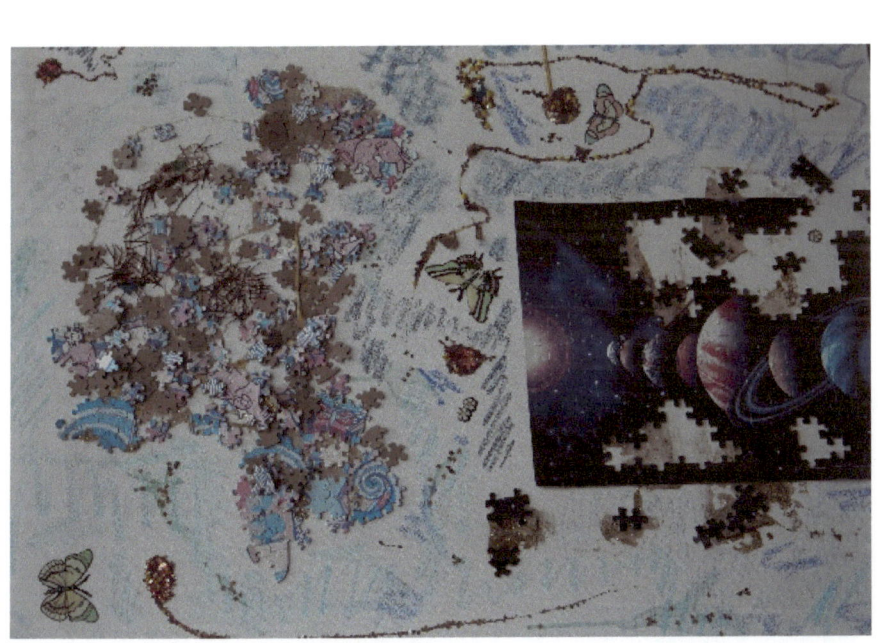

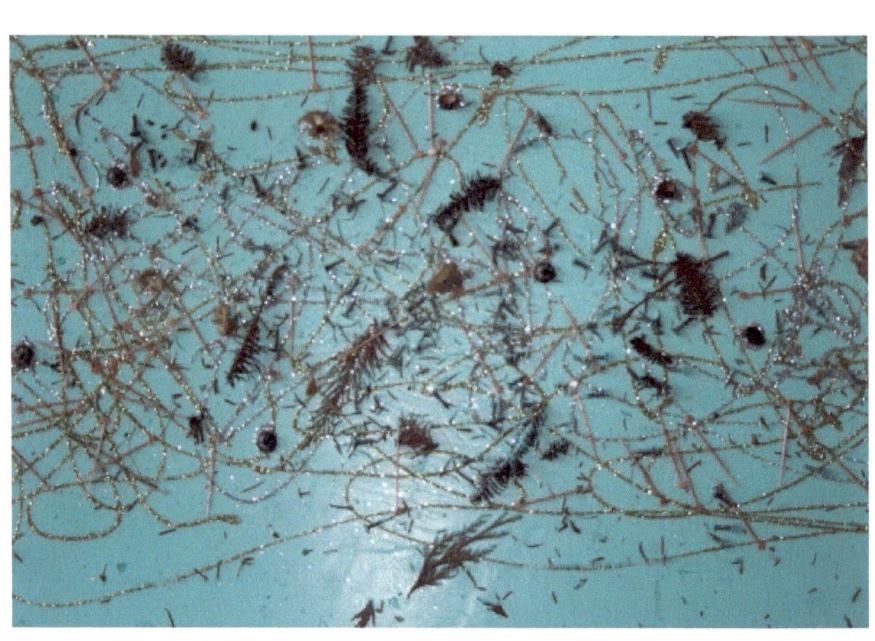

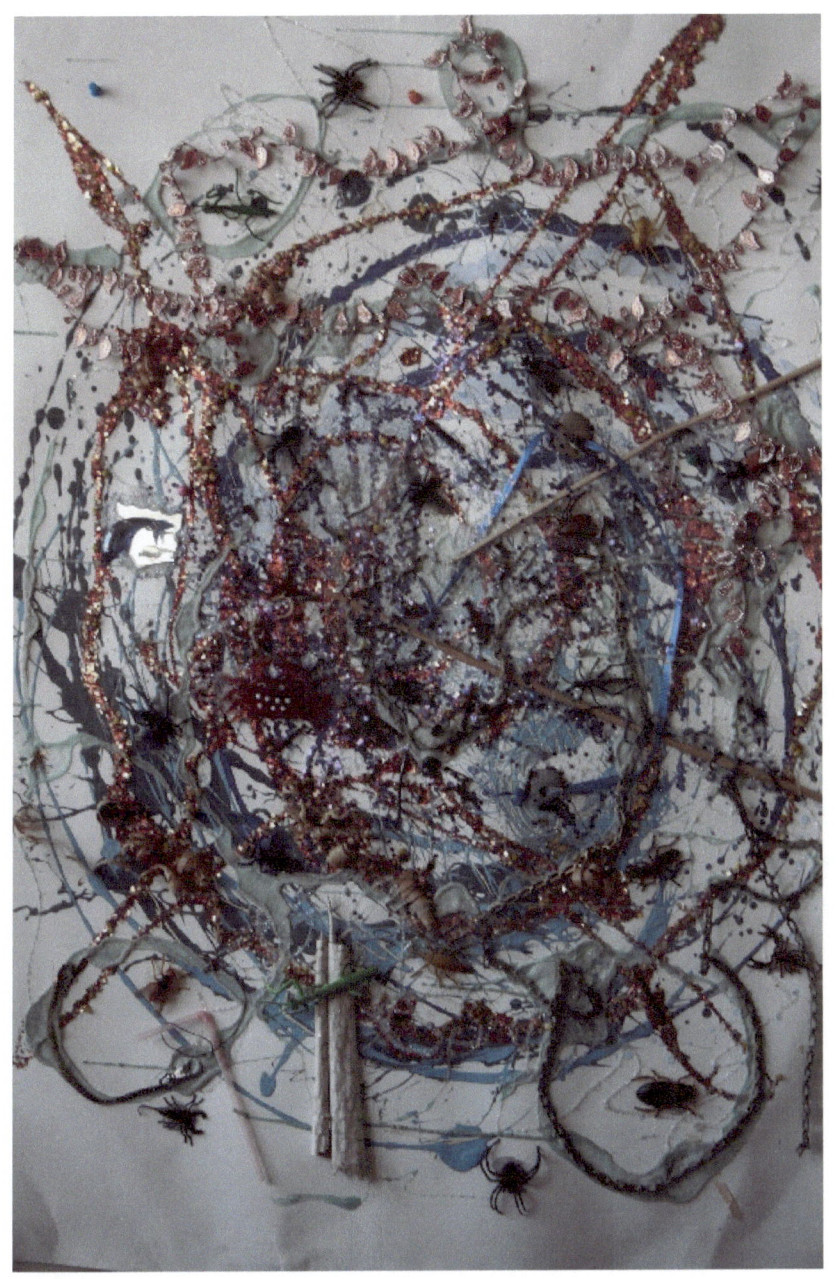

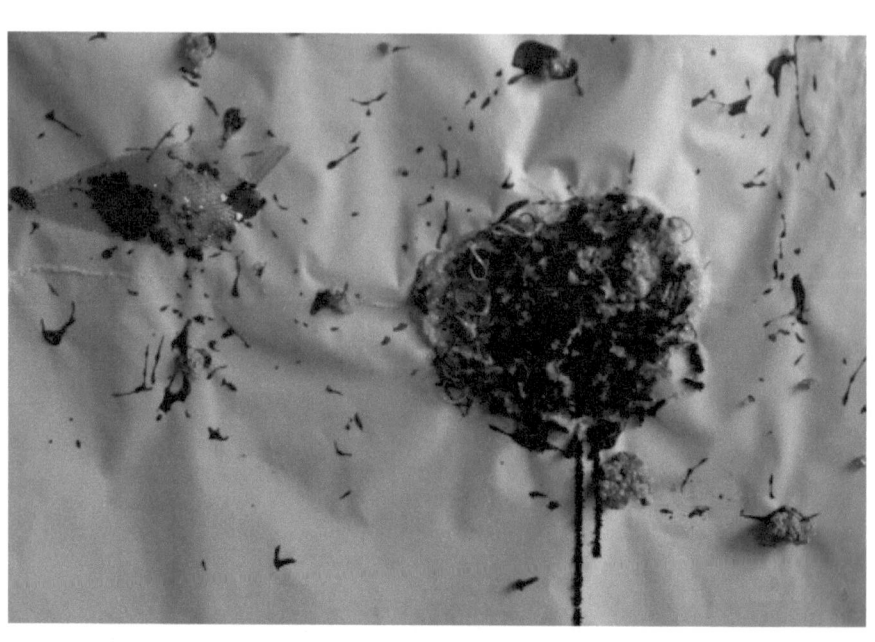

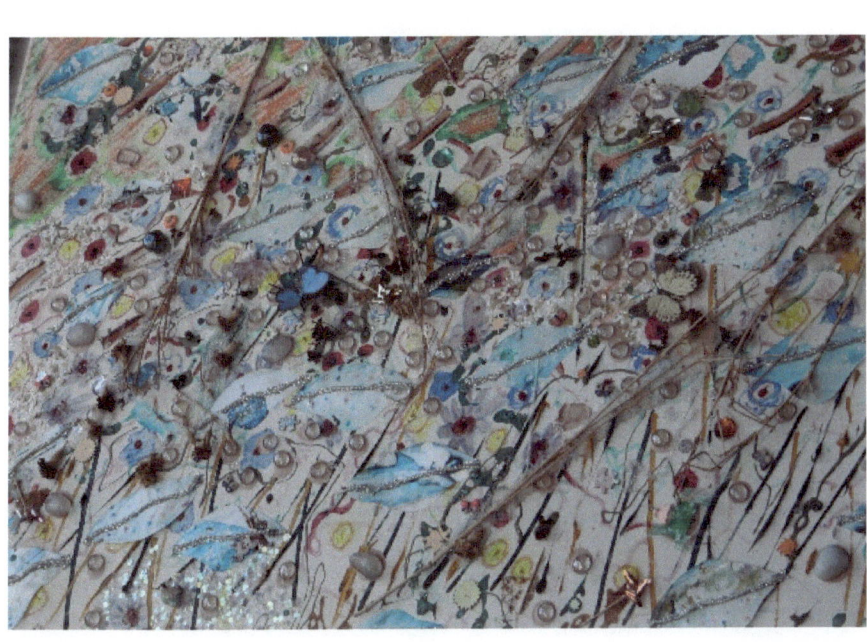

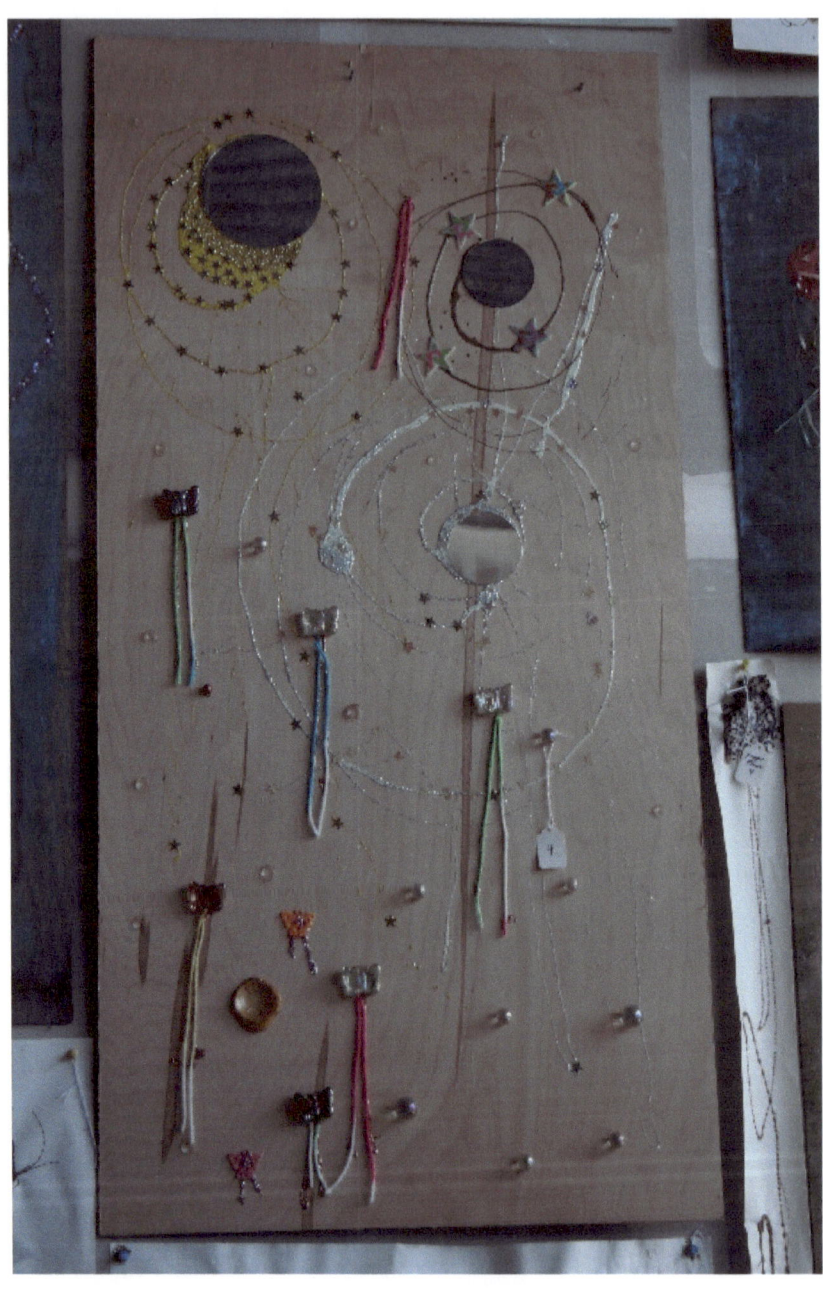

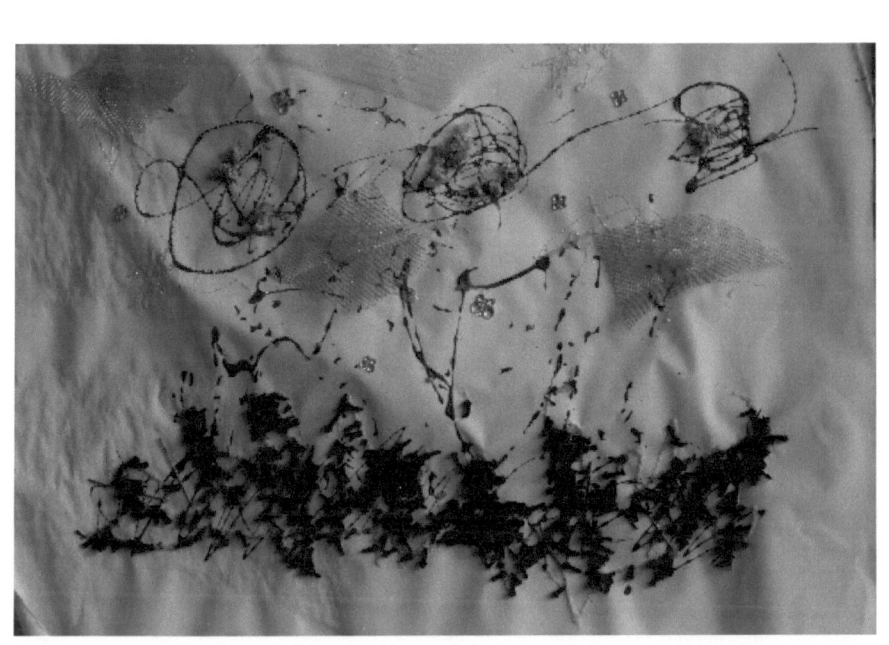

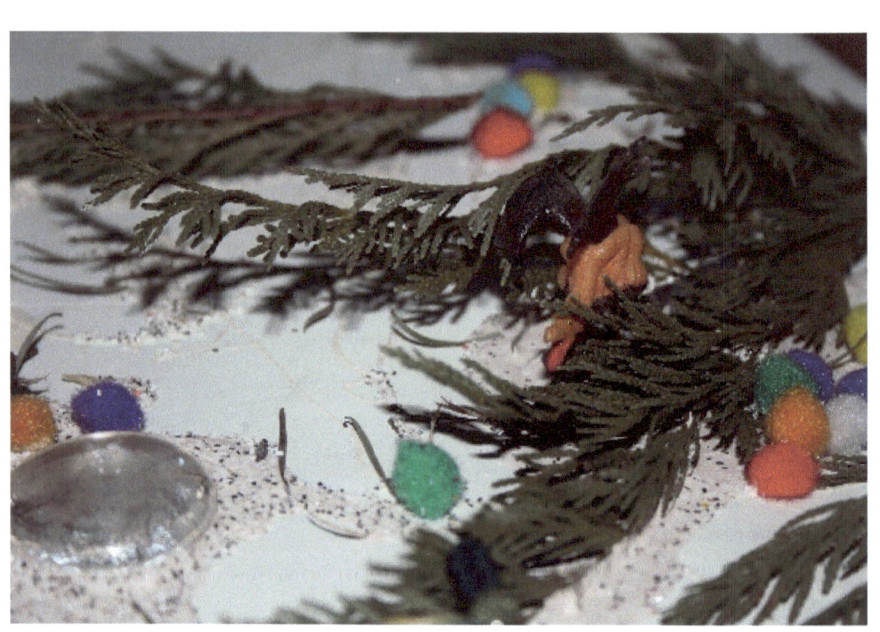

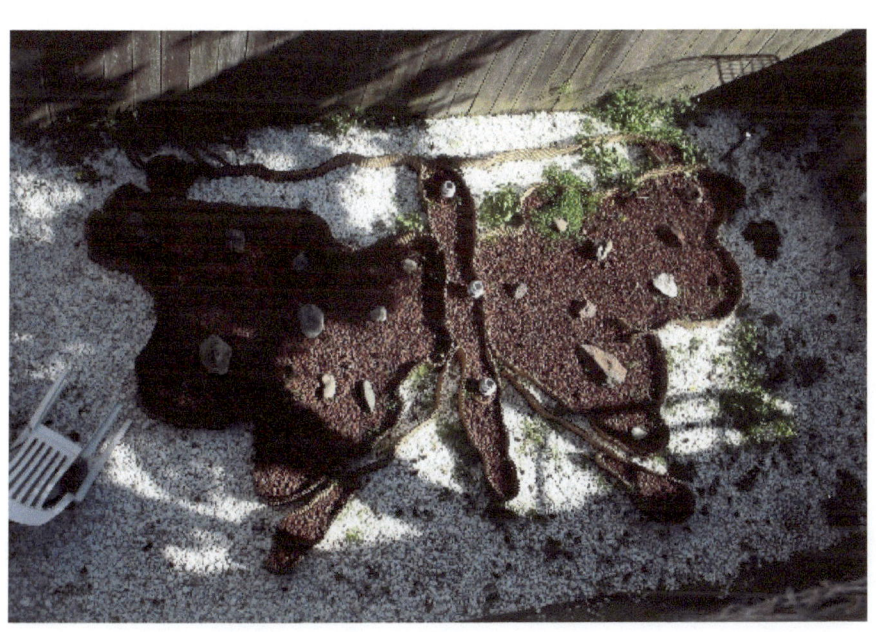

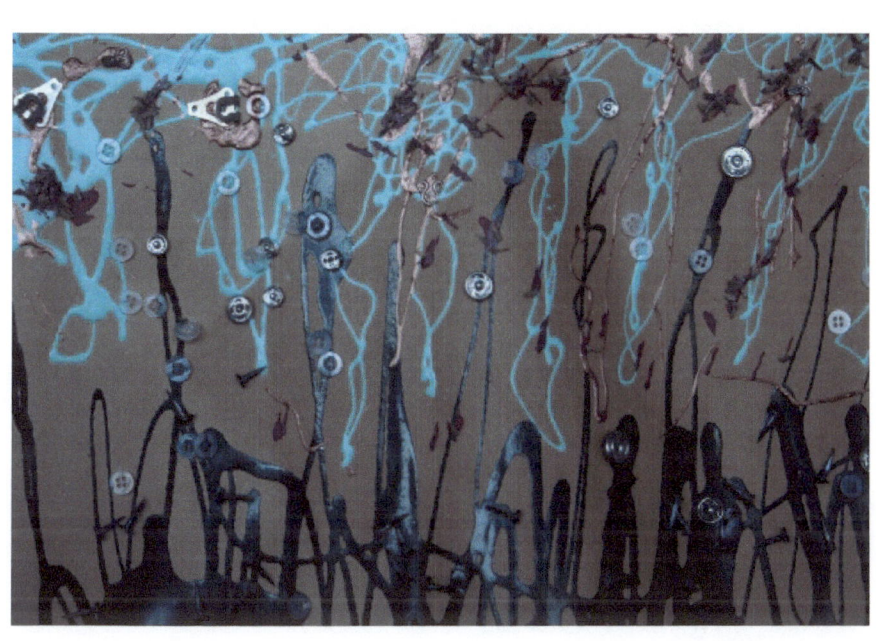

Sabrina Royce has created hundreds of original works of Art starting at age 2 and continuing to today. These pages are but a sampling of her collection. She has also discovered that cooking is a lot like creating a work of Art. Picking the materials, pouring, stirring, waiting, testing, trying again and always looking for just that perfect balance of ingredients, chemistry and love. She is now integrating the Healing Arts into her various Creative Arts endeavors aiming for the perfect recipe.

And now a word of advice from the Author

"Don't eat the Art unless it is Food Art!"

www.ingramcontent.com/pod-product-compliance
Lightning Source LLC
Chambersburg PA
CBHW041622180526
45159CB00002BC/972